LIFE

with Mother

LIFE
with Mother

THE FAMILY THAT RUNS TOGETHER
A mother and son brave the heat as they sprint
across a dune in Death Valley, California.
Photograph by Gordon Wiltsie

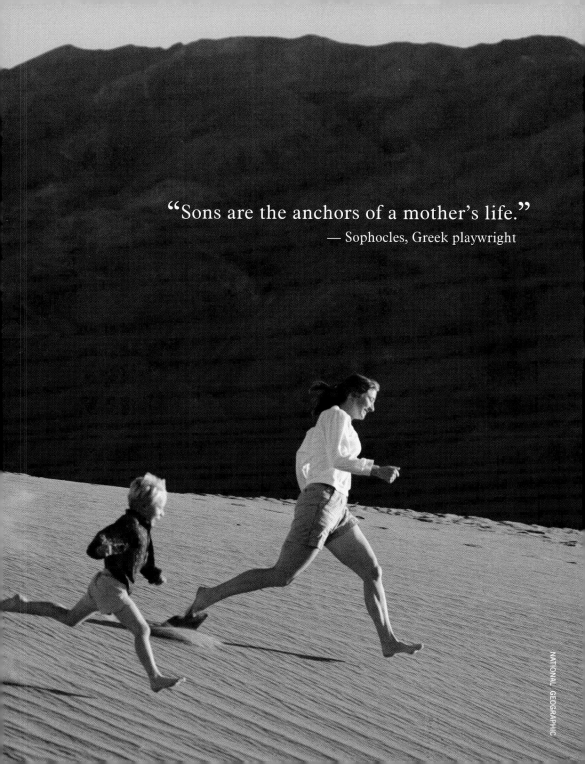

"Sons are the anchors of a mother's life."
— Sophocles, Greek playwright

LIFE Books

EDITOR Robert Sullivan
DIRECTOR OF PHOTOGRAPHY
Barbara Baker Burrows
DEPUTY PICTURE EDITOR
Christina Lieberman
CREATIVE DIRECTOR Michael Roseman
COPY CHIEF Barbara Gogan
PHOTO ASSISTANT Forrester Hambrecht

PRESIDENT Andrew Blau
BUSINESS MANAGER Roger Adler
BUSINESS DEVELOPMENT MANAGER
Jeff Burak

EDITORIAL OPERATIONS
Richard K. Prue (Director),
Brian Fellows (Manager), Keith Aurelio,
Charlotte Coco, John Goodman,
Kevin Hart, Norma Jones, Mert Kerimoglu,
Rosalie Khan, Patricia Koh, Marco Lau,
Brian Mai, Po Fung Ng, Lorenzo Pace,
Rudi Papiri, Robert Pizaro, Barry Pribula,
Clara Renauro, Donald Schaedtler, Hia Tan,
Vaune Trachtman, David Weiner

TIME INC. HOME ENTERTAINMENT

PUBLISHER Richard Fraiman
GENERAL MANAGER Steven Sandonato
EXECUTIVE DIRECTOR, MARKETING SERVICES
Carol Pittard
DIRECTOR, RETAIL & SPECIAL SALES
Tom Mifsud
DIRECTOR, NEW PRODUCT DEVELOPMENT
Peter Harper
ASSISTANT DIRECTOR, BOOKAZINE MARKETING
Laura Adam
ASSISTANT DIRECTOR, BRAND MARKETING
Joy Butts
ASSOCIATE COUNSEL Helen Wan
BOOK PRODUCTION MANAGER
Suzanne Janso
DESIGN & PREPRESS MANAGER
Anne-Michelle Gallero
BRAND MANAGER Shelley Rescober

SPECIAL THANKS TO
Glenn Buonocore, Susan Chodakiewicz, Margaret Hess,
Jennifer Jacobs, Brynn Joyce, Robert Marasco,
Brooke Reger, Mary Sarro-Waite, Ilene Schreder,
Adriana Tierno, Alex Voznesenskiy

ISBN 10: 1-60320-057-6
ISBN 13: 978-1-60320-057-8
Library of Congress Number: 2009900523

"LIFE" is a trademark of Time Inc.

We welcome your comments and suggestions about
LIFE Books. Please write to us at:
LIFE Books
Attention: Book Editors
PO Box 11016
Des Moines, IA 50336-1016

If you would like to order any of our hardcover Collector's
Edition books, please call us at 1-800-327-6388
(Monday through Friday, 7:00 a.m.–8:00 p.m.,
or Saturday, 7:00 a.m.–6:00 p.m., Central Time).

Classic images from the pages and covers of LIFE are now
available. Posters can be ordered at www.LIFEposters.com.

Fine art prints from the LIFE Picture Collection and the
LIFE Gallery of Photography can be viewed at
www.LIFEphotographs.com.

Endpaper illustration courtesy of Susan Patterson

SPIC AND SPAN
Everything is neat and orderly in
Los Angeles as drivers deliver fresh diapers
and mothers with babies line the street.
Photograph by Ralph Crane

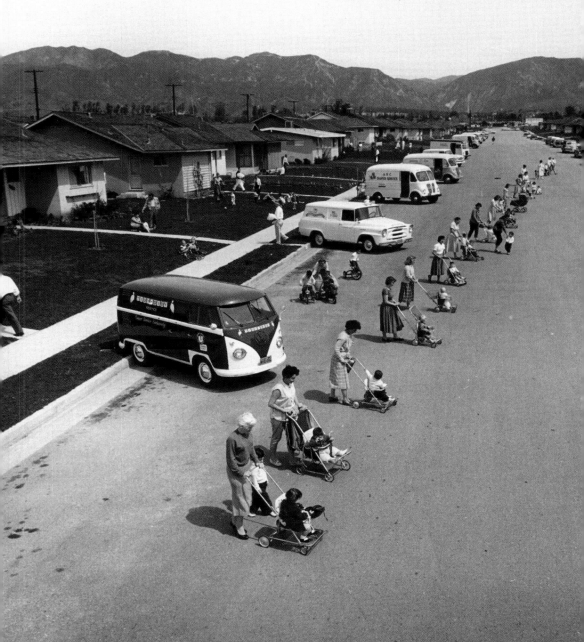

"Any mother could perform the jobs of several air traffic controllers with ease."

— Lisa Alther, American novelist

INTRODUCTION

We are all of woman born. In unbroken descent from our earliest human ancestors, we share that legacy. Indeed, both the Bible and modern science, in their different ways, point to an original Eve, the mother of us all. She may have lived in the Garden of Eden or in ancient Africa, but go back far enough in time, delve deeply enough into most cultures, and there she is. She stands at the head of humanity's great tribe of mothers, all of them essential beyond what words can convey.

The power of a mother is formidable, and so is the responsibility. A loving and tender mother will launch a child in one direction, while a distant or cold mother may set that child on quite a different course. A devoted mother can help sustain her child through the normal cares and woes of life. A mother has a unique capacity to elicit joy—and is in a unique position to alleviate pain.

The relationship between mother and child is the primordial connection. It begins, in most cases, before birth, then extends and deepens throughout infancy and childhood. We say "in most cases" because certainly mothers who adopt their children love them no less and are no less crucial in their children's lives. They are no less Mom.

We venerate our mothers, and with good reason. They are the ones who nurtured us. They are the ones who dried our tears. They are the ones who urged us on and proudly applauded our accomplishments. They are the ones who stood by us always. They are the ones who first loved us unconditionally and continue to love us unconditionally.

It is right to honor them. It is right to celebrate them. It is right to remember the many special moments with our mothers, moments of warmth and comfort that are unmatched by any other experience.

And so we at LIFE have returned to motherhood, one of our favorite topics, and have reimagined a lovely picture book that we first published more than a decade ago. This brand new edition of *LIFE with Mother* contains some classic images from our archives, and many more that are entirely new to our pages. We visit some well-known mothers herein, and many more who modestly, almost anonymously, go about the day-to-day of the most important job on earth.

In this book, every day is Mother's Day.

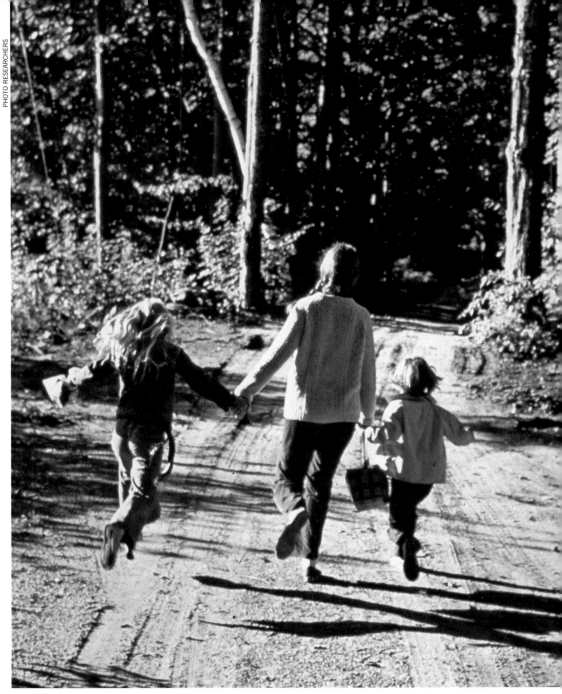

LATE FOR SCHOOL
Massachussets mom Molly Scott runs down the road with her children.
Photograph by Suzanne Szasz

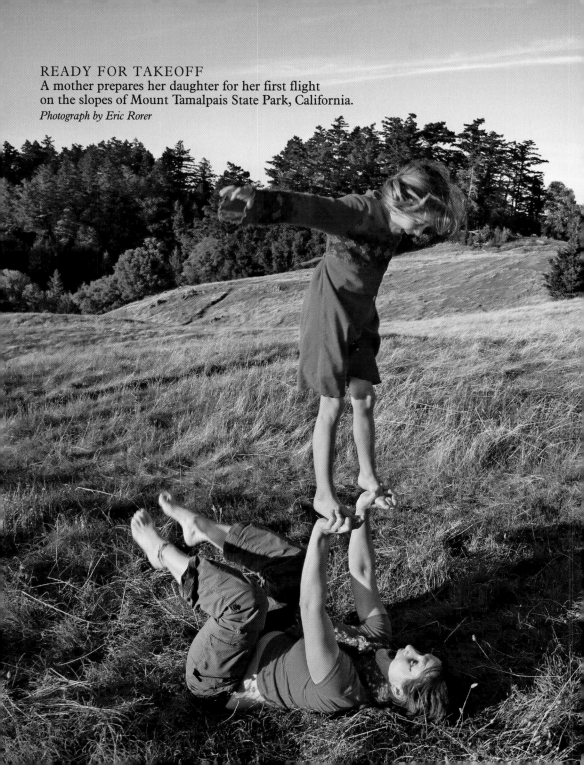

READY FOR TAKEOFF
A mother prepares her daughter for her first flight
on the slopes of Mount Tamalpais State Park, California.
Photograph by Eric Rorer

"What I wanted most for my daughter was that she be able to soar confidently in her own sky, whatever that may be."
— Helen Claes, American mother

"One hour with a child is like a 10-mile run."
— Joan Benoit Samuelson, American marathon champion

SAYING IT WITH FLOWERS
Keegan Markgraf gives his mother, Kate, a Mother's Day present,
just before her soccer match.
Photograph by Andy Mead

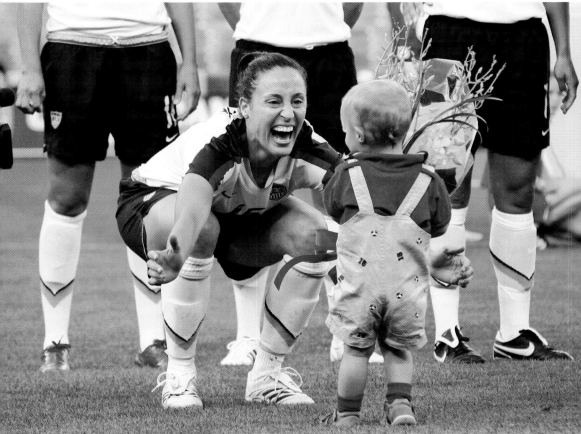

ZUMA PRESS

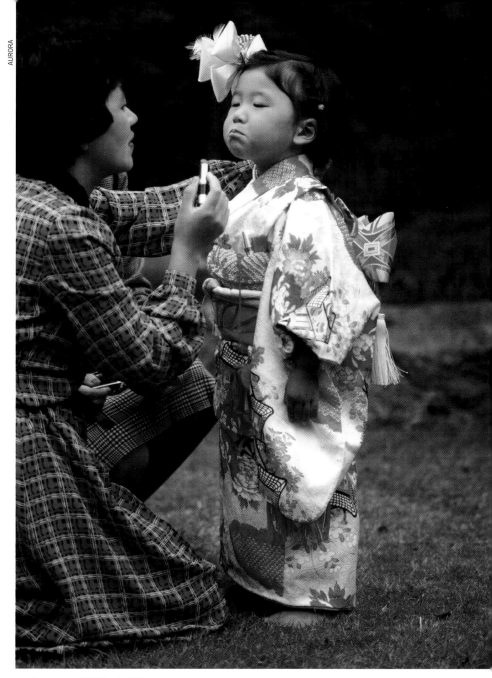

NO POUTING, NOW
Three-year-old Mayuko is not sure what she thinks as her mother, Misuzu Shiba, prepares her for the Shichi-Go-San Festival in Kyoto, Japan.
Photograph by Cary Wolinsky

"Of all the rights of women, the greatest is to be a mother."

— Lin Yutang, Chinese writer

A DAY IN THE LIFE
Near Shipshewana, Indiana, an Amish mother
passes on her tradition of simplicity to her daughter.
Photograph by David Turnley

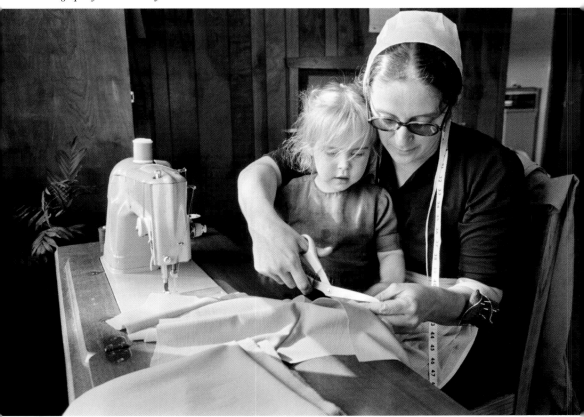

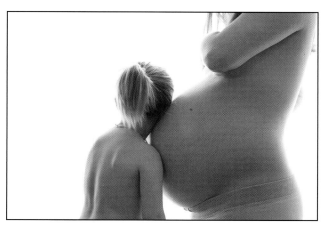

TOMORROW: BIG SISTER
Della Rose gets to know her little brother one day early.
Photographs by Woods Wheatcroft

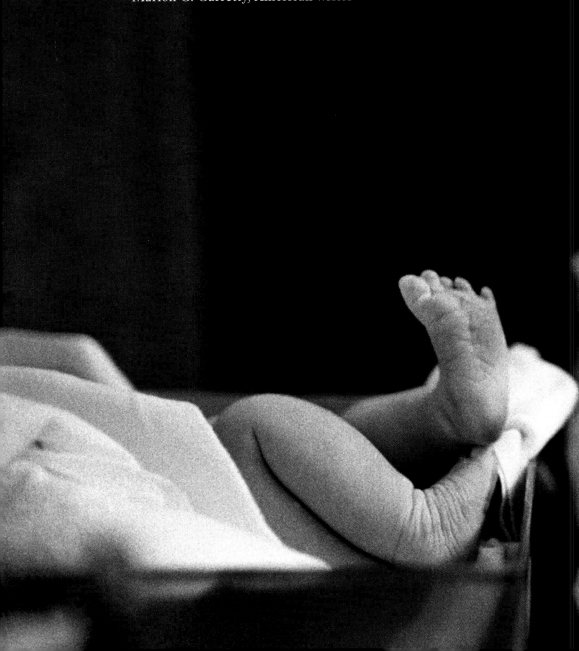

Mother love is the fuel that enables a normal
human being to do the impossible."
— Marion C. Garretty, American writer

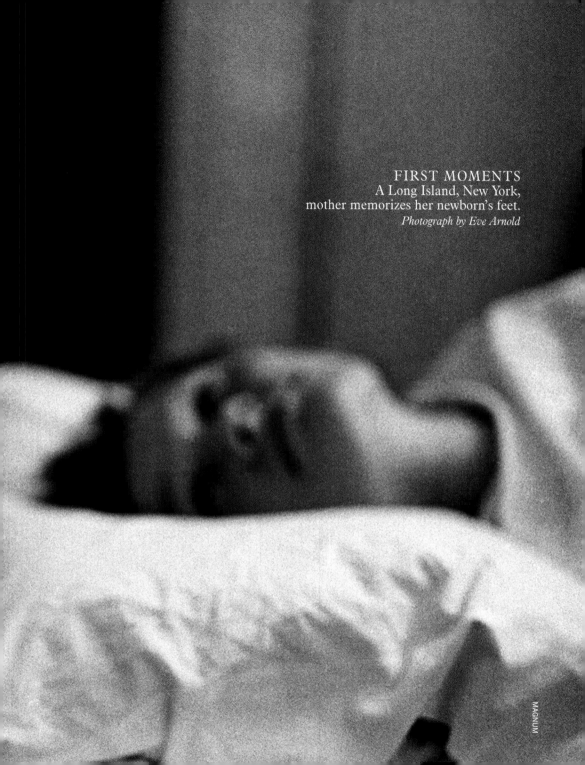

FIRST MOMENTS
A Long Island, New York,
mother memorizes her newborn's feet.
Photograph by Eve Arnold

"For the hand that rocks the cradle
Is the hand that rules the world."
— William Ross Wallace, American poet

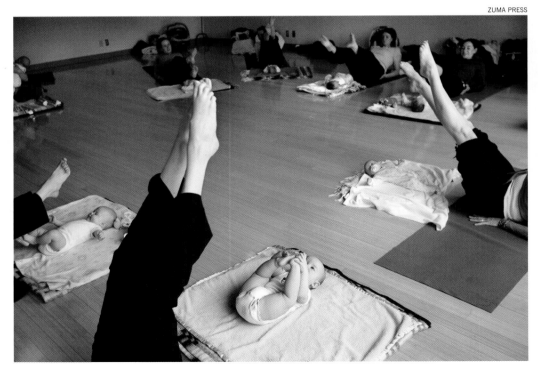

LIFT, ONE, TWO, THREE
Yoga starts early for babies and moms in St. Louis Park, Minnesota.
Photograph by Jennifer Simonson

LOVING HANDS
Eleven-month-old Kaleigh Grable is caressed by her mother in Talladega, Alabama.
Photograph by David McLain

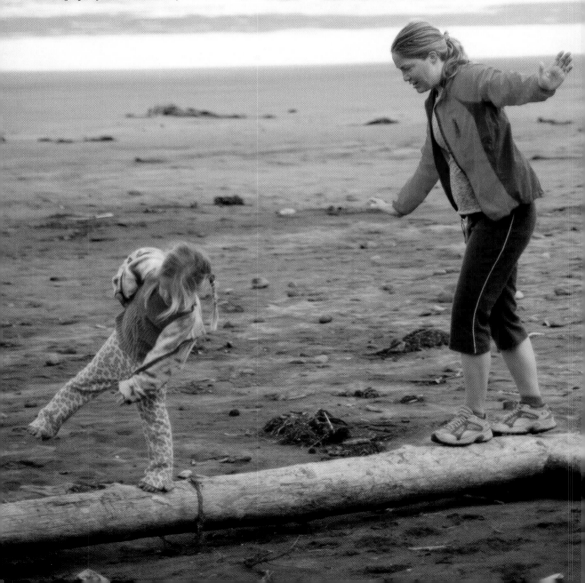

BALANCING ACT
On Agate Beach in Oregon, Holly Walker
and her daughter, Della Rose, practice their circus act.
Photograph by Woods Wheatcroft

"Chance made you my daughter;
love made you my friend."
— Anonymous

AURORA

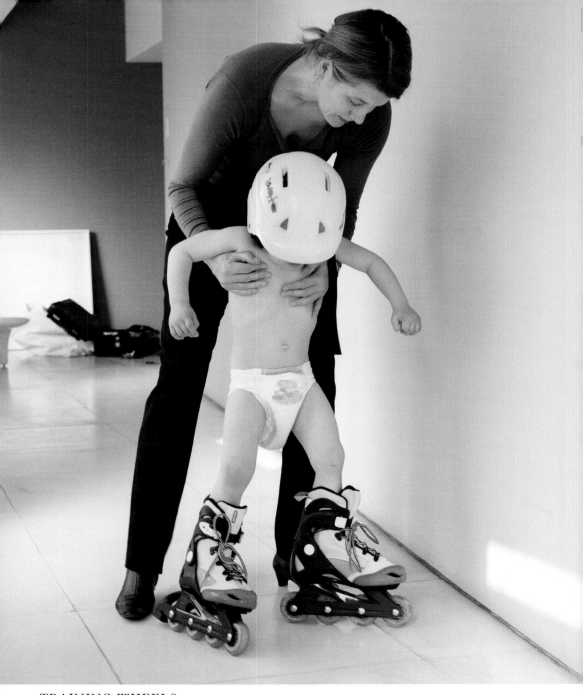

TRAINING WHEELS
In London, Fiona Naylor starts her son Theo rolling in the right direction.
Photograph by Peter Marlow

"Life began with waking up
and loving my mother's face."

— George Eliot, British novelist

WATER BABIES
Also in London, moms and tots try to beat the July heat.
Photograph by Cate Gillon

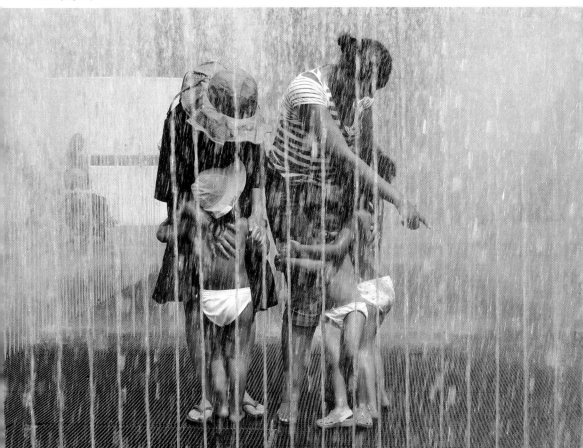

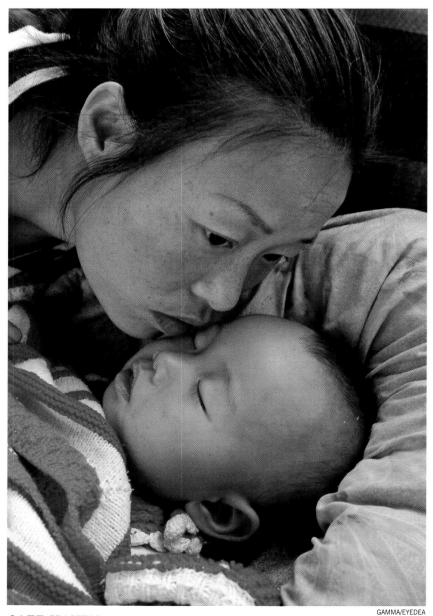

SAFE HAVEN
After an earthquake in Sichuan Province, China,
a mother and child take refuge in a tent in Longnan City.
Photograph by Wang Zhiheng

"Your Heaven lies under the feet of your mother."

— Muhammad

THE VIGIL
In Baghdad's Alilwiya Children's Hospital,
a mother wipes her tears away, hoping
for the best for her premature baby.
Photograph by Graeme Robertson

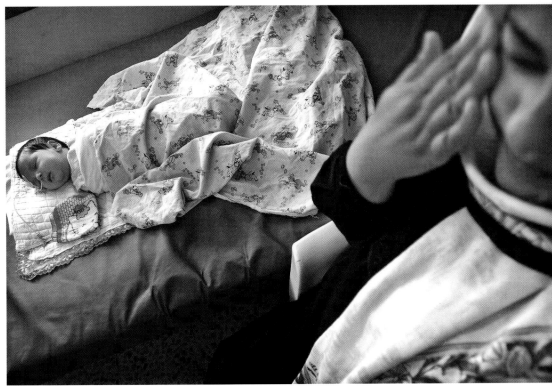

> "Mother's love grows by giving."
> — Charles Lamb, British essayist

A SECOND GIFT OF LIFE
Aisia Palma strokes her recovering daughter, Brooklyn,
after doctors in San Diego have transplanted
a portion of her liver into the thirteen-month-old girl.
Photograph by Nadia Borowski Scott

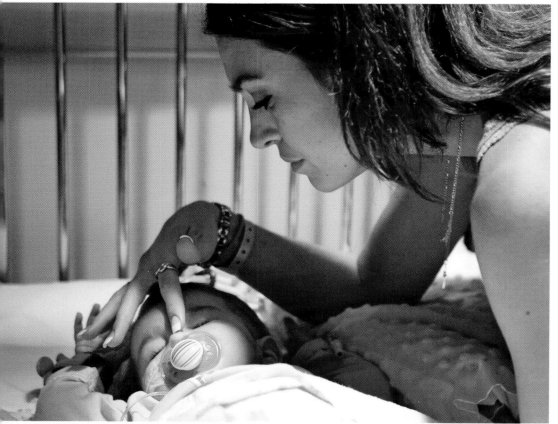

ZUMA PRESS

LIKE MOTHER, LIKE SON
Mom coaches her son on how to take the plunge
at a pool on the island of Corsica in the Mediterranean.
Photograph by Peter Marlow

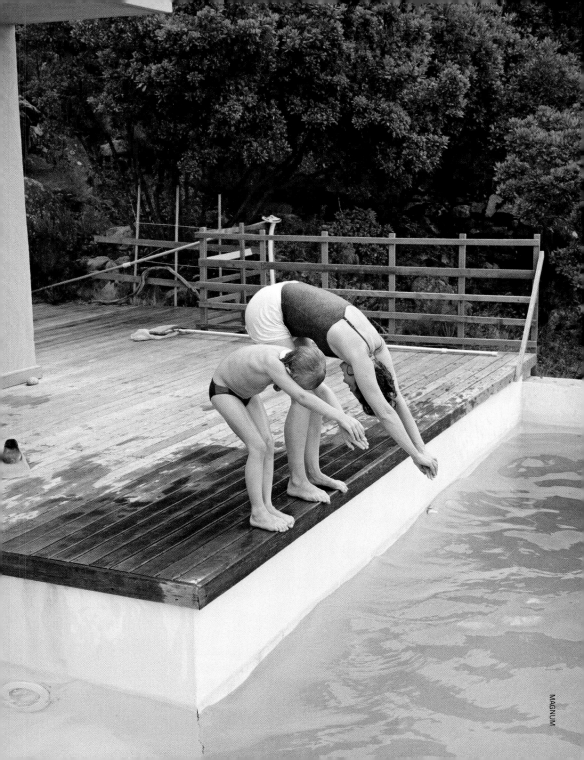

SCHOLARS AND FUTURE SCHOLARS
Six moms at St Andrews University in Scotland
balance the demands of school and children.
Photograph by Andrew Milligan

"All mothers are rich when they love their children."
— Maurice Maeterlinck, Belgian writer

NOSE TO NOSE
A bride and her mother in Normandy, France, share a quiet moment.
Photograph by France Keyser

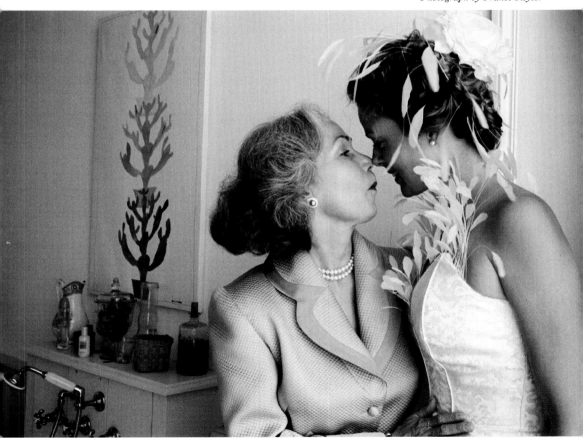

> "[M]other is one to whom you hurry when you are troubled."
>
> — Emily Dickinson, American poet

THE FORK IN THE ROAD
Yasmin Azel and her mother watch the Maine fog come in.

Photograph by Jose Azel

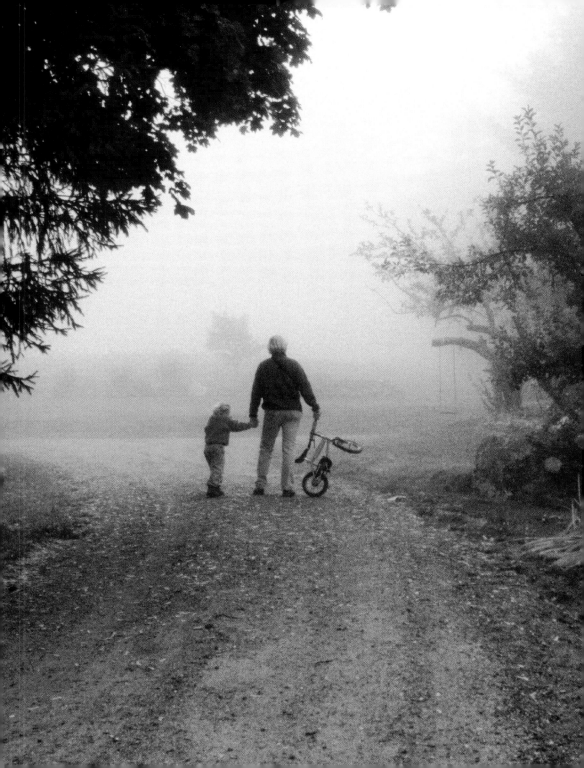

"I really learned it all from mothers."
— Dr. Benjamin Spock, American pediatrician

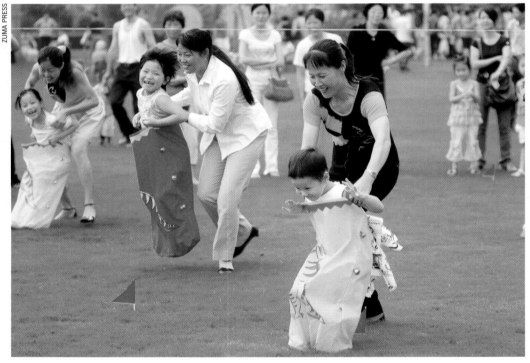

HIP HOPPING
Kindergartners and moms giggle through a sack race in Xiamen, China.
Photograph by Zhang Xiangyang

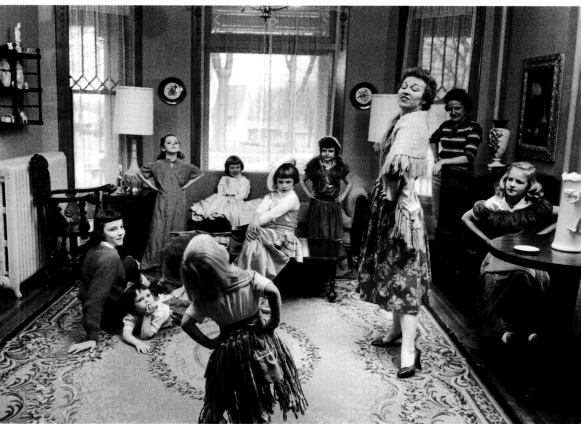

LIFE

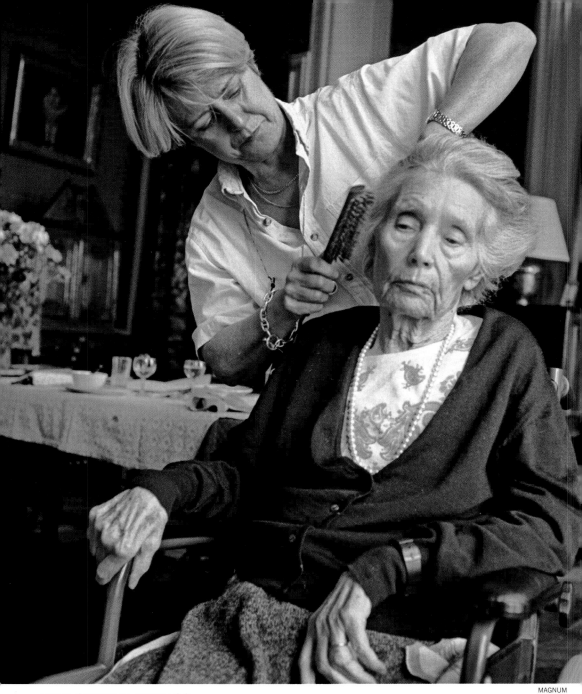

THE SIMPLE THINGS
Isabelle Gautier helps her Parisian mother look her best.

Photograph by Guy Le Querrec

"As is the mother, so is her daughter."

— Ezekiel 16:44

TOGETHER AT LAST
After three years as refugees, two sisters are finally reunited with their mother
in Sierra Leone, through the efforts of the International Rescue Committee.
Photograph by Anthony Suau

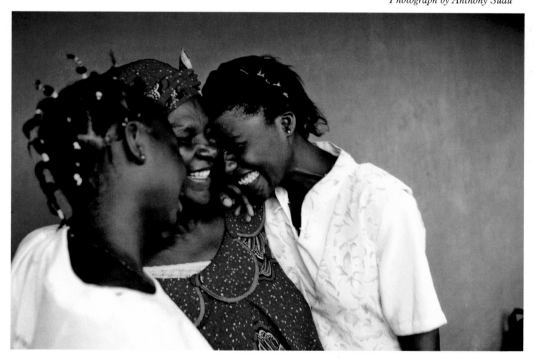

"Becoming a mother makes you the mother of all children."

— Charlotte Gray, Canadian historian

EVERYBODY, CLAP TOGETHER
Kami Kolhana cheers with her newly adopted daughter, Nika, in West Palm Beach, Florida . . .
Photograph by Uma Sanghvi

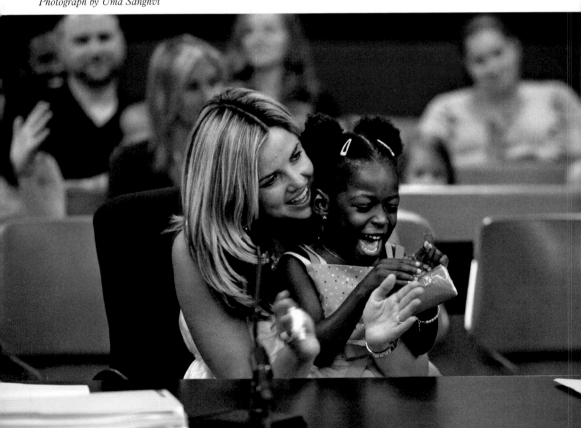

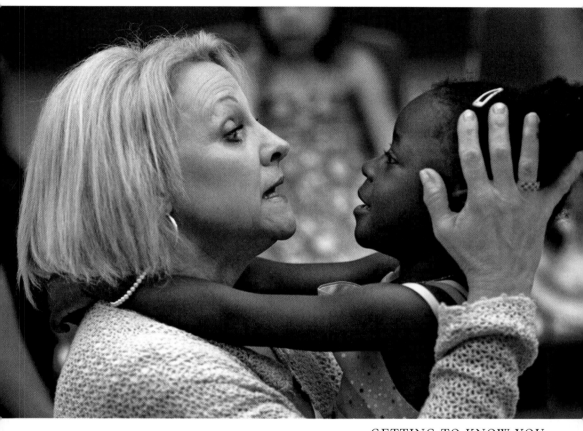

GETTING TO KNOW YOU
And then, Nika gazes back at her new grandmother's face.
Photograph by Uma Sanghvi

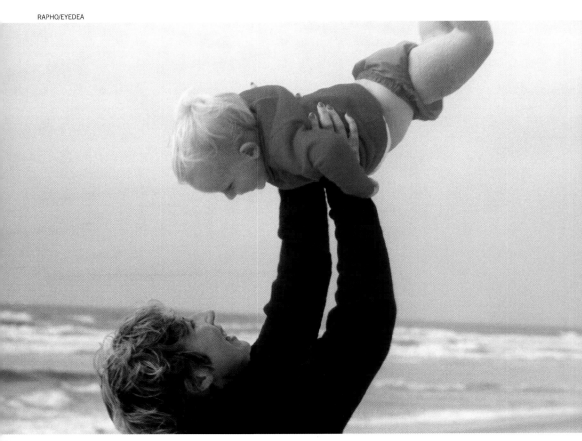

LIGHT LIFTING
Every baby is Superman in his mother's arms.
Photograph by Janine Niepce

"Only mothers can think of the future—because they give birth to it in their children." — Maxim Gorky, Russian dramatist

FLOOR EXERCISE
In Seoul, South Korea, single mother
Cho Sun-ae cradles her month-old son, Kwon Chan-hyuk.
Photograph by Patti Gower

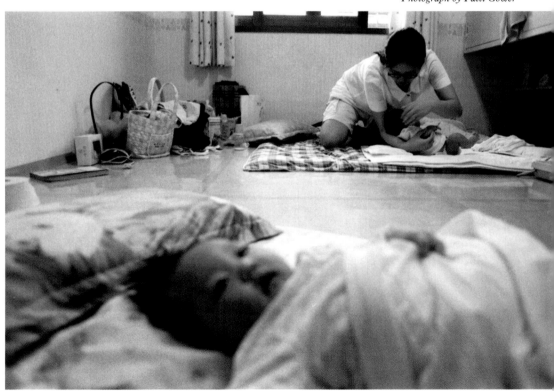

"All mothers are working mothers."
— Anonymous

IN THESE FIELDS
Even with a young daughter, this cotton picker near Tibni, Syria, still has to bring in the harvest.
Photograph by James L. Stanfield

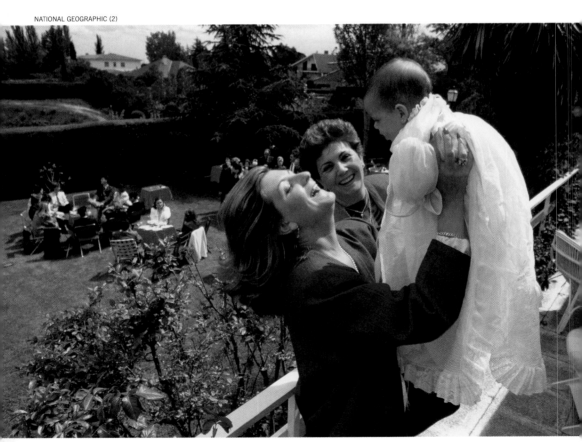

WELCOME TO THE FOLD
A mother celebrates her daughter's christening in Madrid, Spain.
Photograph by O. Louis Mazzatenta

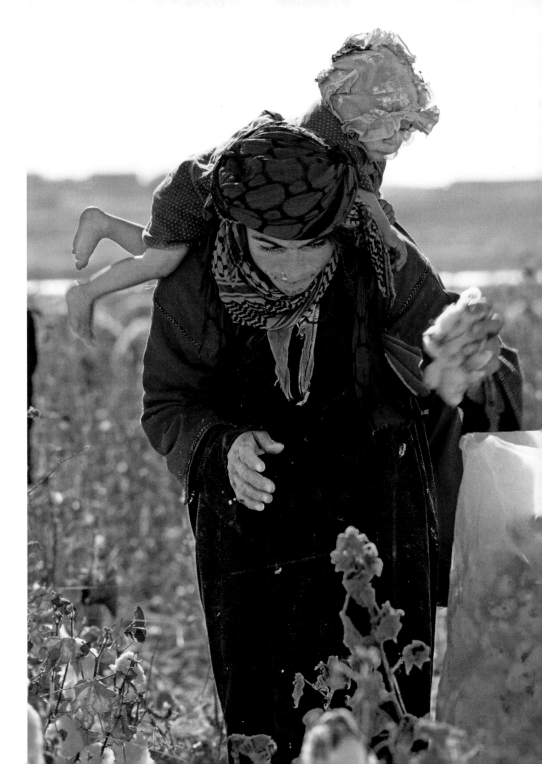

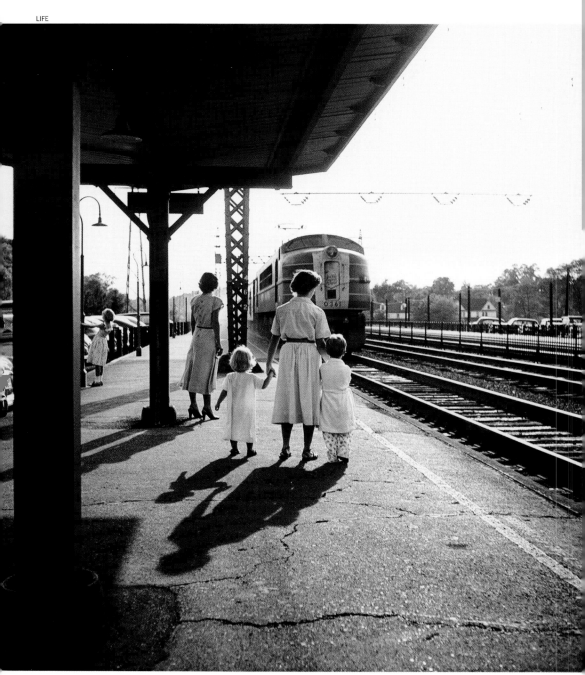

ARRIVING ON THE 6:26
In Darian, Connecticut, Mom and kids eagerly wait for Dad's train.
Photograph by Nina Leen

> "It takes as much discipline to be a mother and a wife as it does to do anything else."
>
> — Suzanne Vega, American singer and songwriter

ALL THAT GLITTERS IS NOT GOLD
Oblivious to the gilt around her, Susie Marks,
a Gypsy living in Spokane, Washington, cradles her newborn.
Photograph by Paul Fusco

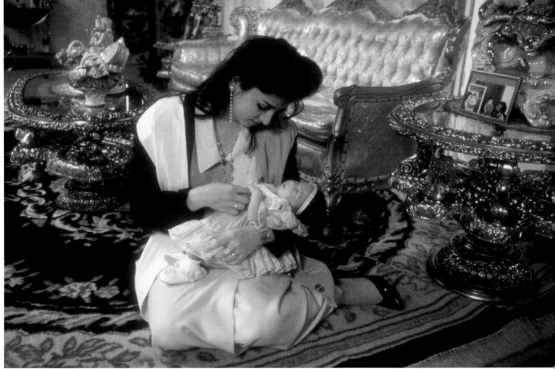

Now let us praise famous women . . .

"My philosophy was always to just let her
grow up and to be there if she needed me."
— Shirley MacLaine, American actress

ACT NATURALLY
Shirley and her daughter, Sachi, mug for the camera.
Photograph by Allan Grant

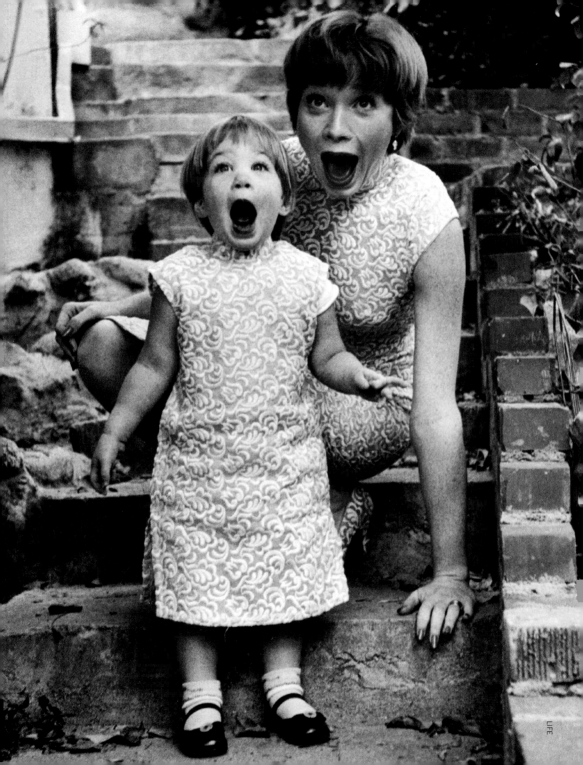

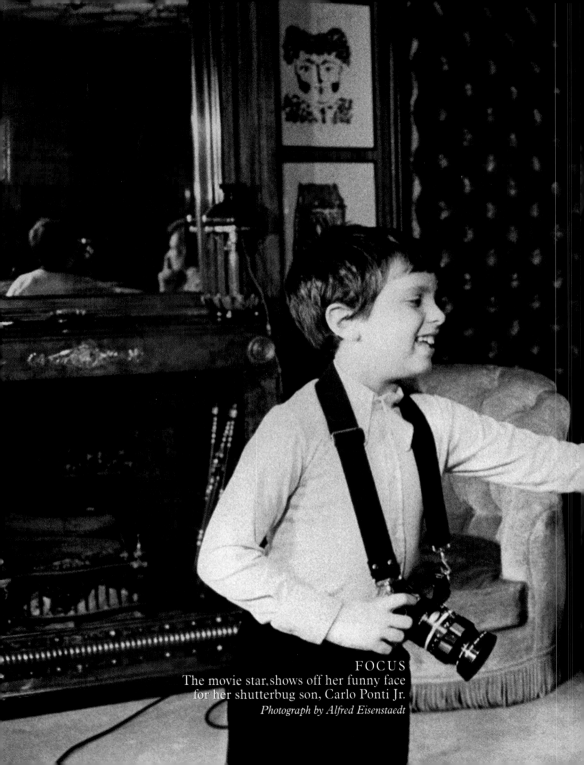

FOCUS
The movie star, shows off her funny face
for her shutterbug son, Carlo Ponti Jr.
Photograph by Alfred Eisenstaedt

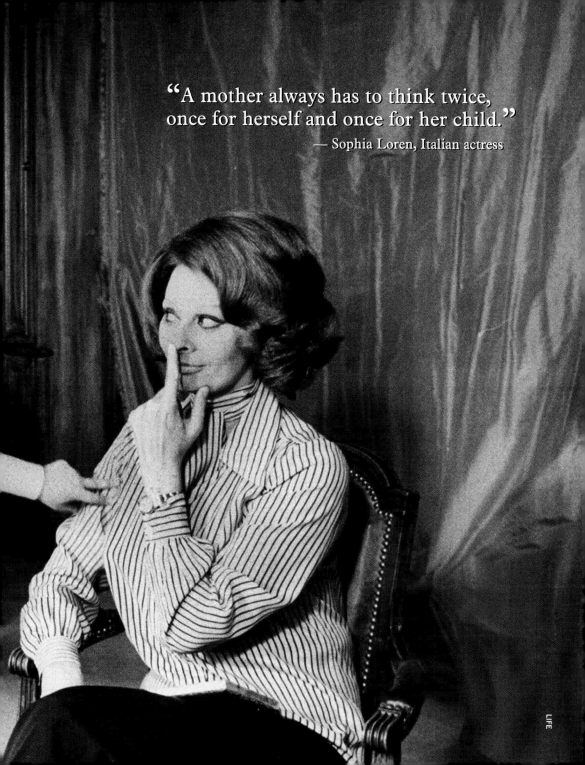

"A mother always has to think twice, once for herself and once for her child." — Sophia Loren, Italian actress

> **"I don't think I ever felt beautiful until I was pregnant and when I gave birth to my children."**
>
> — Vanessa Redgrave, British actress

SLEEPY TIME
Liza Todd enjoys a quiet moment in the embrace
of her mother, actress Elizabeth Taylor.
Photograph by Toni Frissell

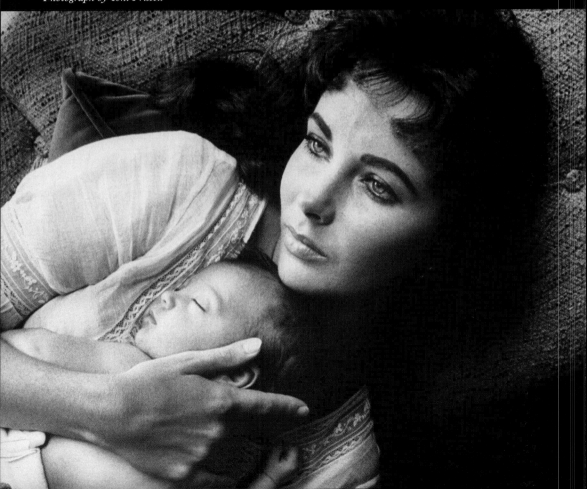

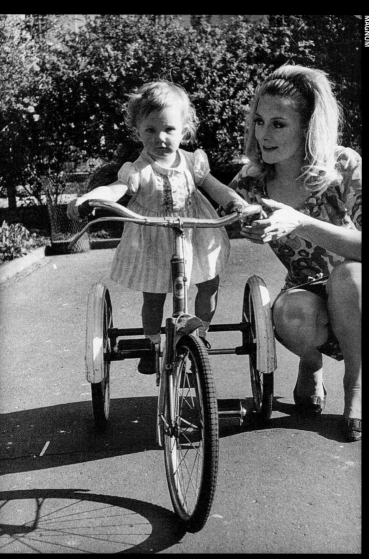

HAVE WHEELS, WILL TRAVEL
Mother Vanessa watches Joely take a spin in London.
Photograph by Eve Arnold

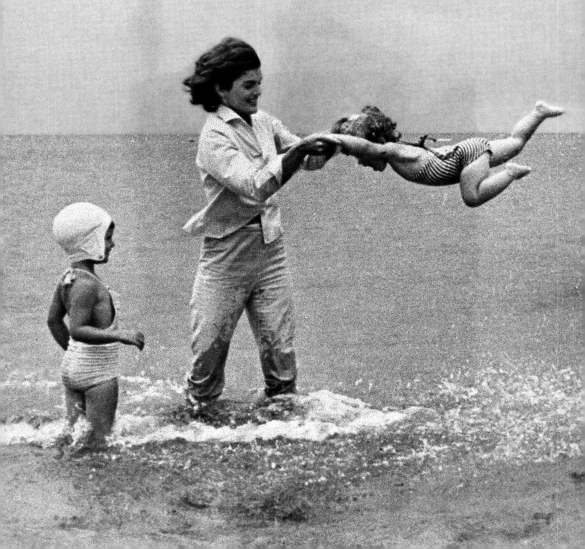

"If you bungle raising your children, I don't think whatever else you do well matters very much."

— Jacqueline Kennedy

SWING TIME
While a young friend watches,
Jackie gives her daughter, Caroline, the thrill of her life.
Photograph by Mark Shaw

SMOOCHES
Little Carrie Fisher enjoys a kiss from her mother, actress Debbie Reynolds, while brother Todd keeps a wary eye on the photographer.
Photograph courtesy Debbie Reynolds

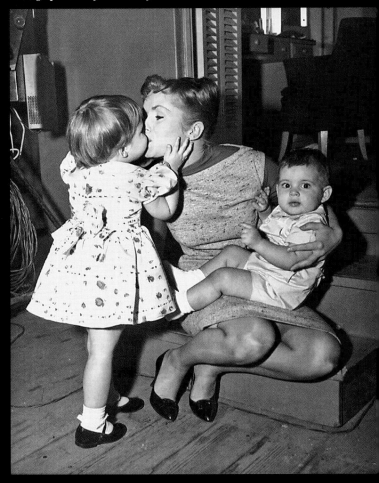

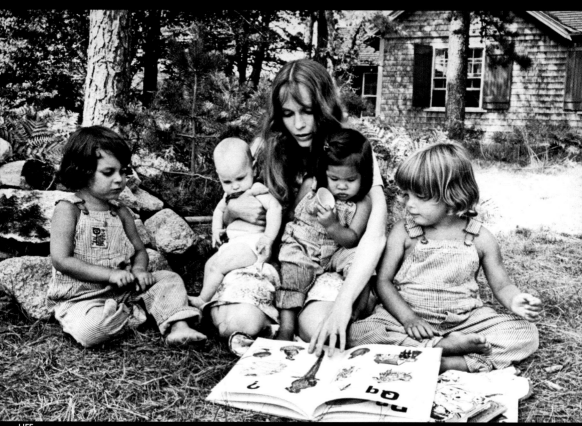

"I have the most wonderful children.
I've been very, very blessed."
— Mia Farrow, American actress

TODAY'S LETTER IS *Q*
Mia reads to her children
on Martha's Vineyard, Massachusetts.
Photograph by Alfred Eisenstaedt

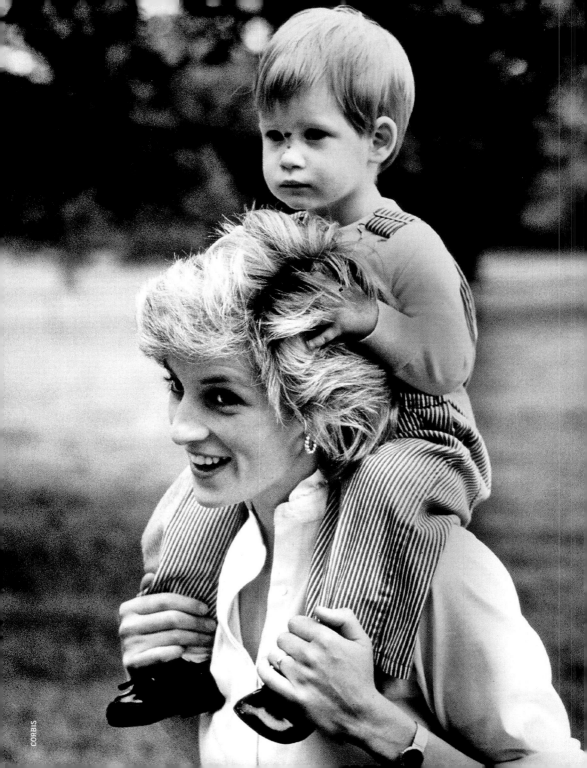

"A mother's arms are more comforting than anyone else's." — Diana, Princess of Wales

SERIOUS BUSINESS
The princess gives her son Prince Harry a ride around the royal estate in Highgrove, England.
Photograph by Tim Graham

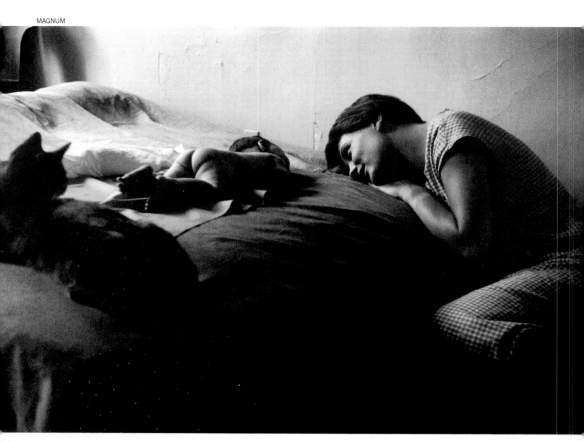

SIX DAYS OLD
New York City mother Lucienne Erwitt loves her baby, and the cat does, too.
Photograph by Elliott Erwitt

"God could not be everywhere
and therefore he made mothers."

— Jewish Proverb

WHO'S THAT BABY?
At first glance, somebody seems a bit unsure.
Photograph by Janine Niepce

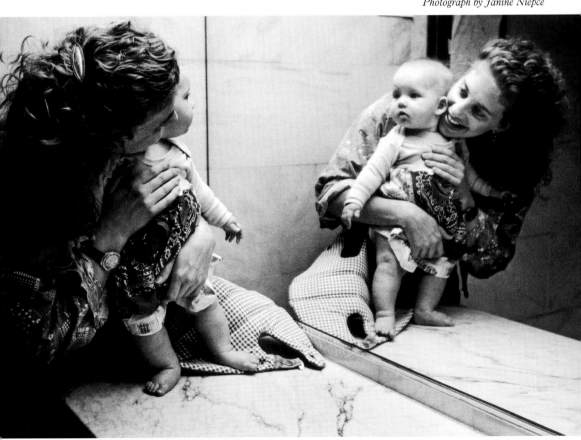

"If love is sweet as a flower, then
my mother is that sweet flower of love."
— Stevie Wonder, musician

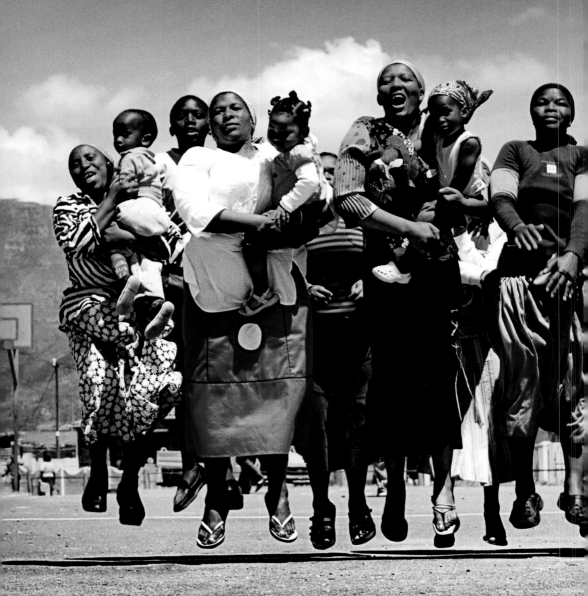

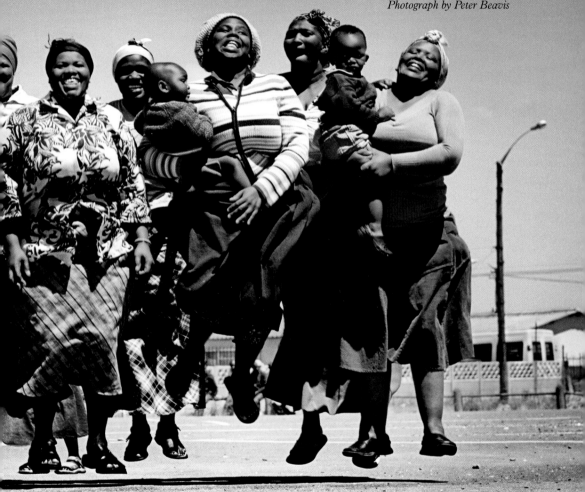

TAKING FLIGHT
In South Africa's Langa Township, mothers and their children leap into the air, just because they can.

Photograph by Peter Beavis

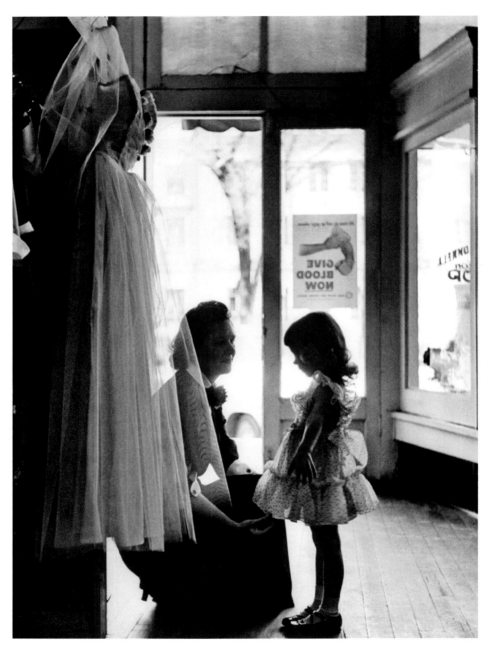

JUST IN TIME FOR EASTER
In Clarksville, Arkansas, Mrs. Boone Bartlett shops
for a spring dress with her daughter Dorothy Kay.
Photograph by Yale Joel

"Mothers and daughters are closest, when daughters become mothers."

— Anonymous

FOUNDING MOTHER
At 109 years old, Wisconsinite Augusta Pagel poses
for a portrait that spans seven generations of her family.
Photograph by Michael O'Brien

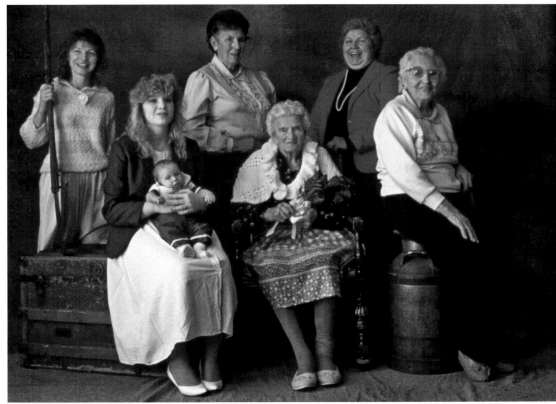

"Mother's love is peace. It need not
be acquired, it need not be deserved."

— Erich Fromm, German psychologist

HOME, SWEET HOME
On a special Mother's Day near Elk Grove, California, Sarah Lucchesi snuggles
with her mother, Kimberly, and new brother, Bennet, after nearly losing both of
them to a serious prenatal illness.
Photograph by Chris Crewell

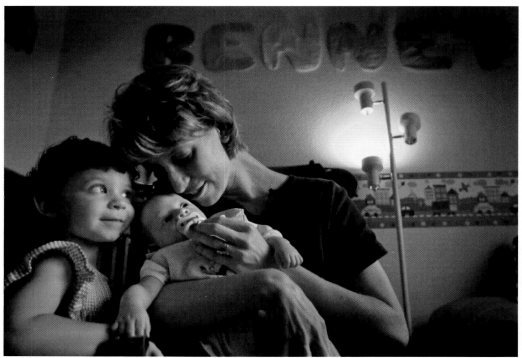

TOPSY-TURVY
Peggy McCloskey and her daughter try on a
different perspective on Deer Isle, Maine.
Photograph by Suzanne Szasz

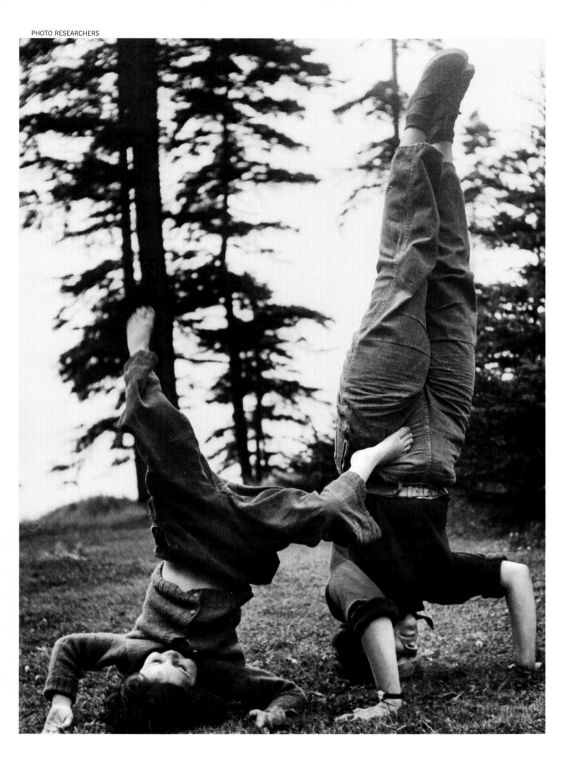

GOOD HUMORS
A Finnish mother laughs at her baby's smile.

Photograph by Franc and Jean Shor

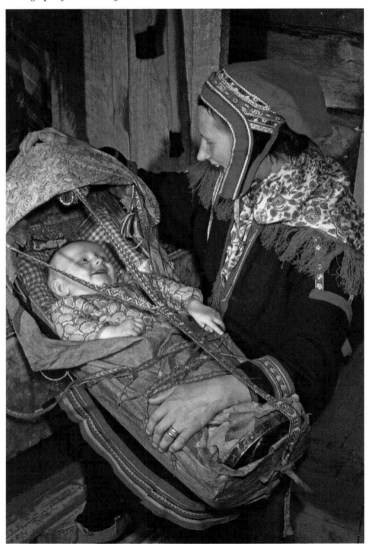

NATIONAL GEOGRAPHIC (2)

"My mom is a neverending song in my heart of comfort, happiness, and being."

— Graycie Harmon, American writer

THE COLORS OF HAPPINESS
Mother, son and dog all enjoy a
roll in the autumn leaves of Atlanta.
Photograph by Joel Sartore

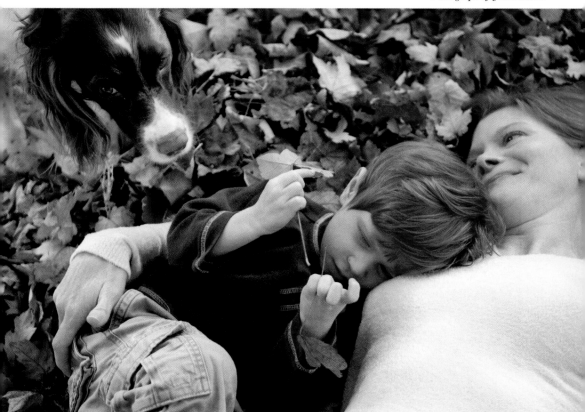

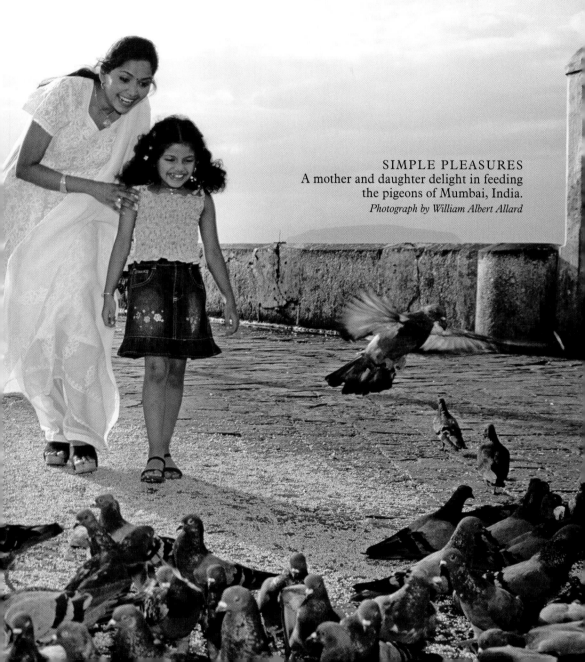

"Who would ever think that so much went on in the soul of a young girl?"
— Anne Frank, Diarist

SIMPLE PLEASURES
A mother and daughter delight in feeding the pigeons of Mumbai, India.
Photograph by William Albert Allard

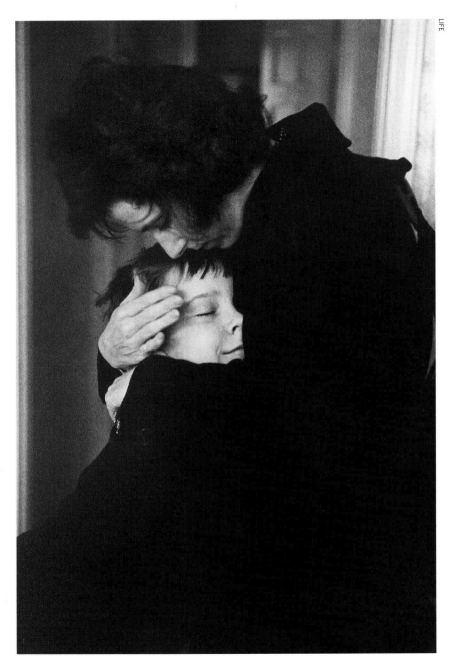

QUALITY TIME
New Jersey mother Doreen Yochum
settles into a hug with her son Geoffrey.
Photograph by Lynn Johnson

> "An ounce of mother is worth a pound of clergy."
>
> — Spanish proverb

SMACKDOWN!
Her two sons tumble this laughing mother
to the ground in Cabin John, Maryland.
Photograph by Skip Brown

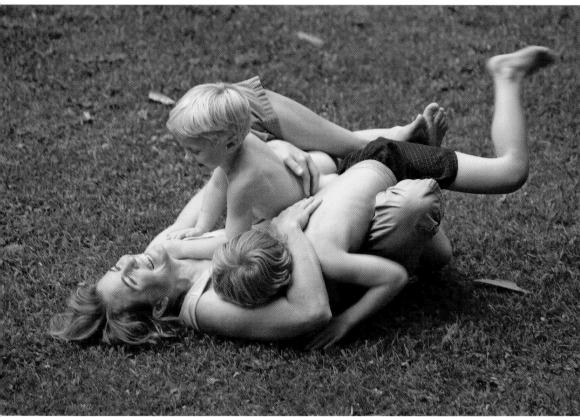

"A mother is a mother still,
The holiest thing alive."

— Samuel Taylor Coleridge, British poet

THEY GROW UP SO FAST
Like so many before her, a mother
in Saint Petersburg, Russia, sends her son off to sea.
Photograph by Cotton Coulson

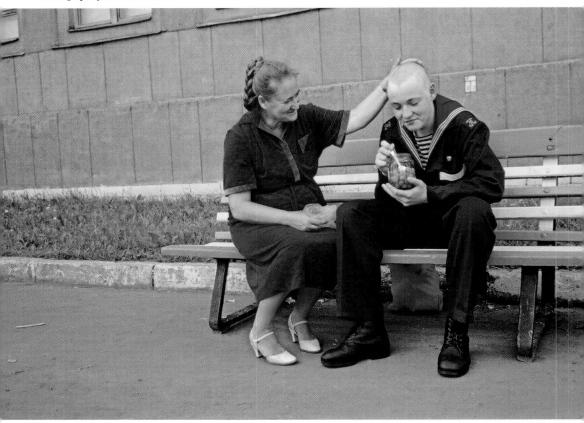

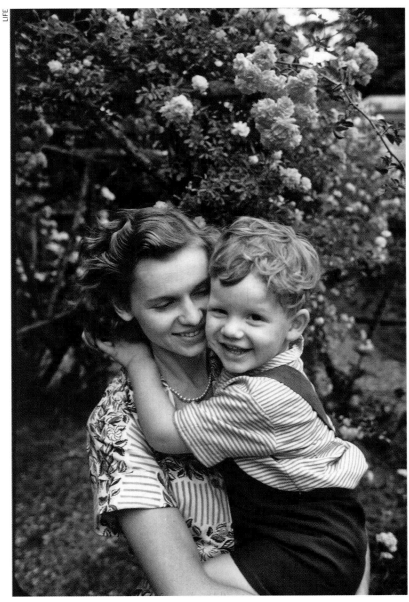

CUDDLES IN AN ENGLISH GARDEN
Russell Burrows happily flings his arms around his mother, Vicky.

Photograph by Larry Burrows

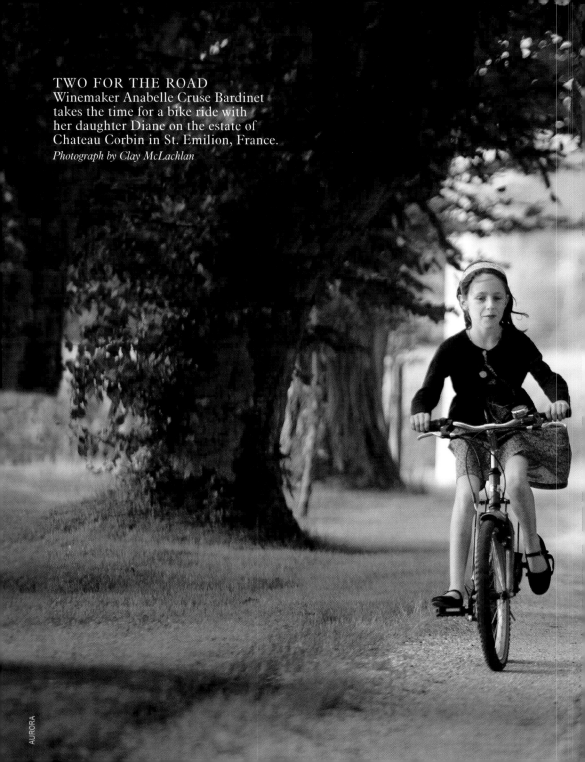

TWO FOR THE ROAD
Winemaker Anabelle Cruse Bardinet
takes the time for a bike ride with
her daughter Diane on the estate of
Chateau Corbin in St. Emilion, France.
Photograph by Clay McLachlan

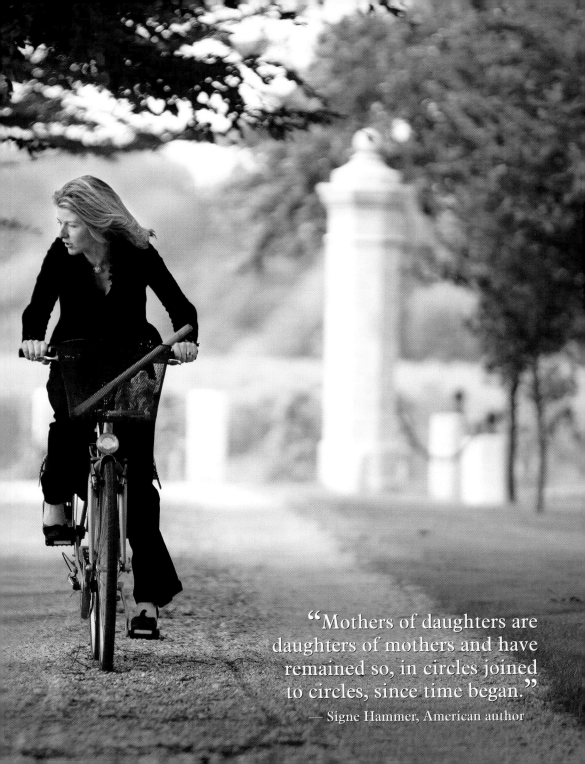

"Mothers of daughters are daughters of mothers and have remained so, in circles joined to circles, since time began."
— Signe Hammer, American author

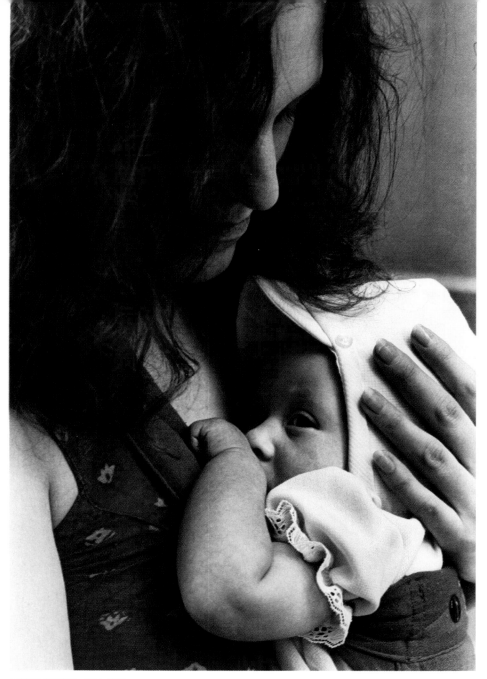

THE TWO OF US
New York City mom Christina Lieberman watches
her daughter, Sarah, watch the world.

Photograph by Joan Harrison

"A daughter needs a mom to provide her with memories that will last forever."
— Gregory Lang, American author

PARTY TIME
A mother and daugher celebrate a
10-year wedding anniversary near Sandpoint, Idaho.
Photograph by Woods Wheatcroft

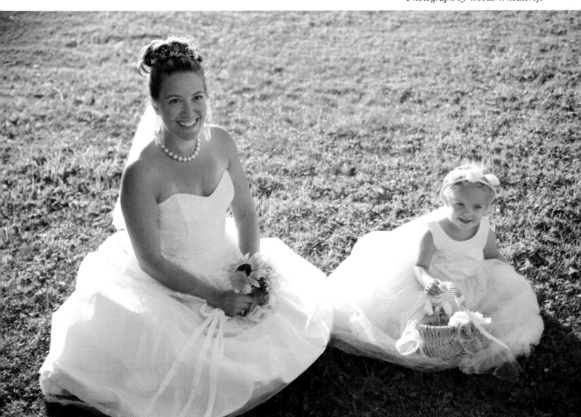

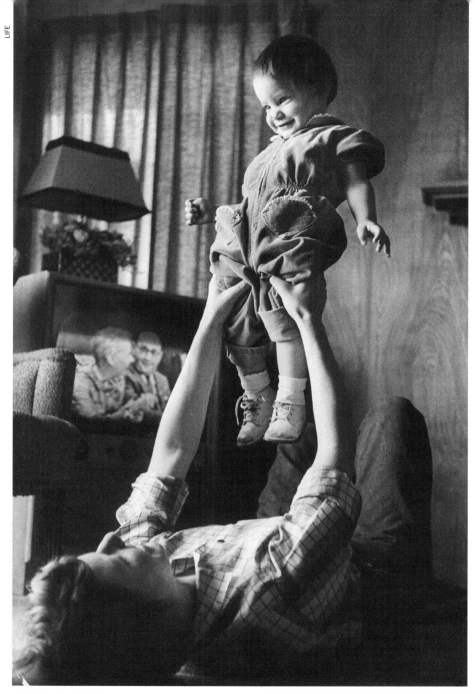

UPSY-DAISY
Mrs. Carroll lifts her son higher and higher, much to his evident delight.
Photograph by Grey Villet

"There is only one pretty child in the world, and every mother has it." — Chinese proverb

SUNDOWN
Nanà and her mother, Paola, share a quiet moment at Cabo de Gata Natural Park, Spain.
Photograph by Ferdinando Scianna

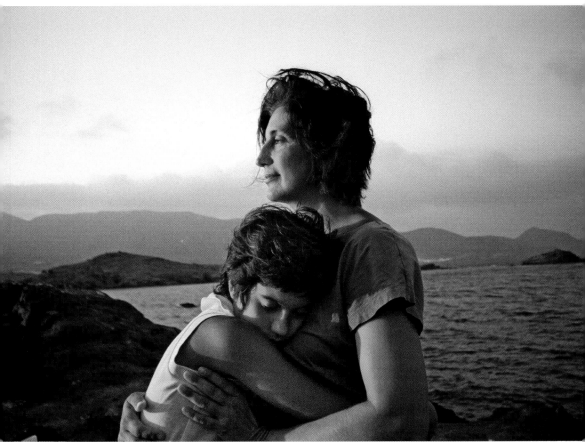

"[Mothers] are the great vacationless class."

— Anne Morrow Lindbergh, wife of Charles Lindbergh

MATERNAL PRIDE

This Russian mom in Saint Petersburg can't stop looking back at her son.

Photograph by Sisse Brimberg

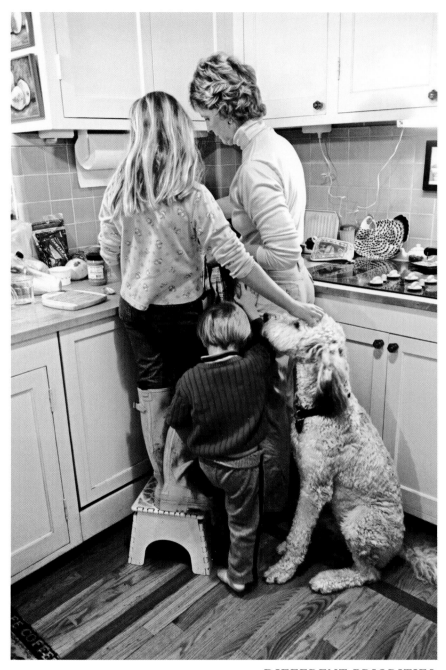

DIFFERENT PRIORITIES
While Ellen and Kathy Satore of Dunbar, Nebraska, wash the dishes,
Spencer tries to get his mom's attention and the dog keeps everyone company.

Photograph by Joel Sartore

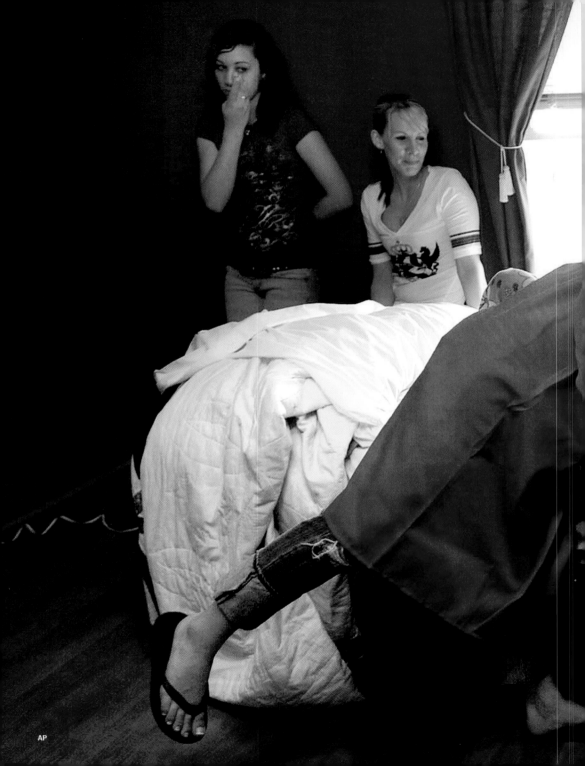

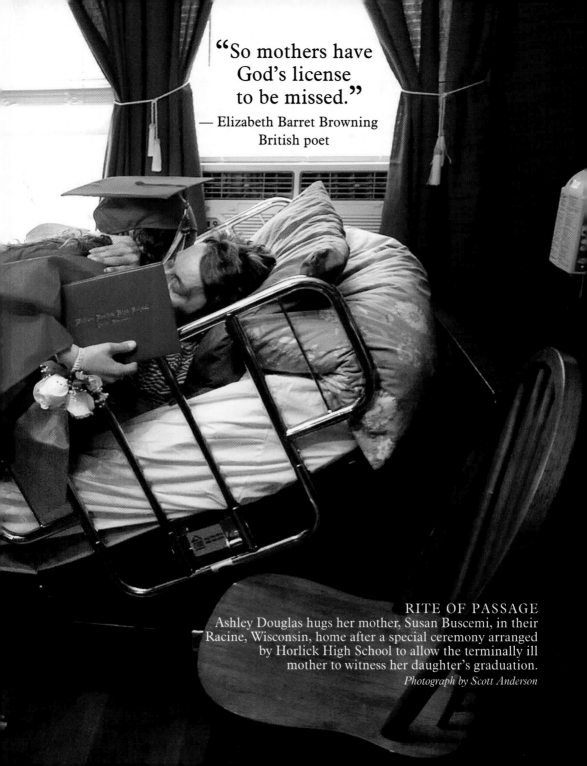

"So mothers have God's license to be missed."
— Elizabeth Barret Browning
British poet

RITE OF PASSAGE
Ashley Douglas hugs her mother, Susan Buscemi, in their Racine, Wisconsin, home after a special ceremony arranged by Horlick High School to allow the terminally ill mother to witness her daughter's graduation.
Photograph by Scott Anderson

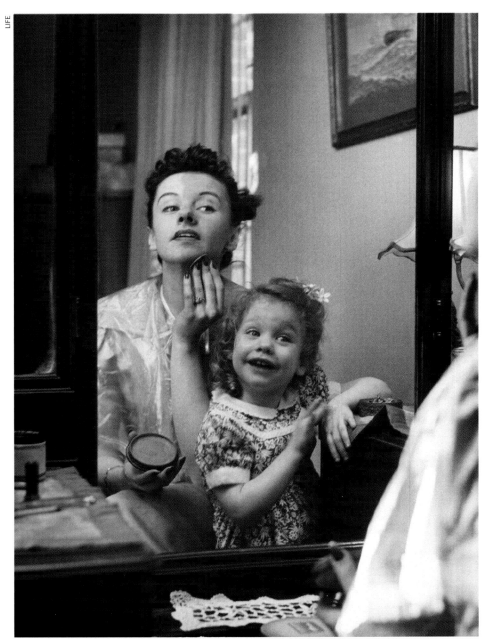

PRIVATE LESSONS
A Tulsa, Oklahoma, daughter takes delight
in learning the basics of beauty from her mother.
Photograph by Nina Leen

"The art of mothering is to teach the art of living to children." — Elaine Heffner, American psychiatrist

MY THREE SONS
Londoner Fiona Naylor sinks into the pillows
with her boys, Max, Felix and Theo.
Photograph by Peter Marlow

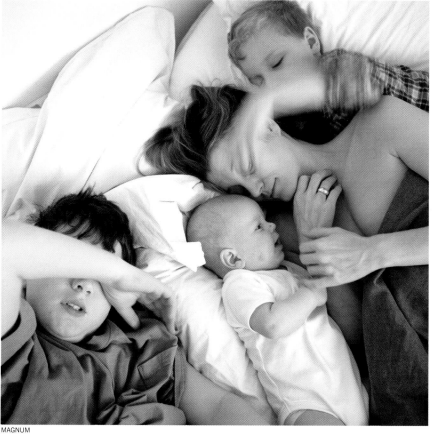

MAGNUM

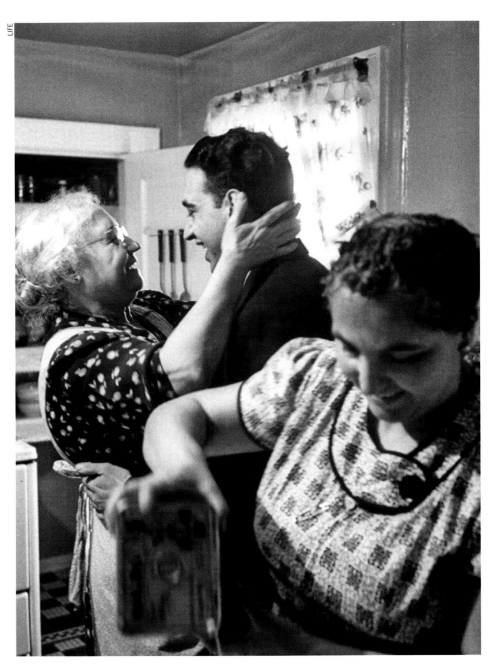

BABY NO MORE
Mrs. Alfonso La Falce kisses her son at a family reunion in Poughkeepsie, New York.
Photograph by Ralph Morse

"What is home without a mother?"

— Septimus Winner, American songwriter

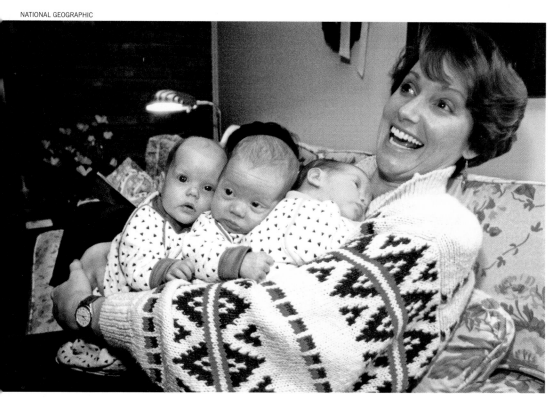

QUITE AN ARMFUL
Her triplets have both stunned and delighted this Maryland mother.
Photograph by Annie Griffiths Belt

BACK TO BASICS
A Kurdish mother nurses her child in the mountains outside Jerusalem.
Photograph by Paul Schutzer

"Most mothers are instinctive philosophers."
— Harriet Beacher Stowe, American abolitionist and author

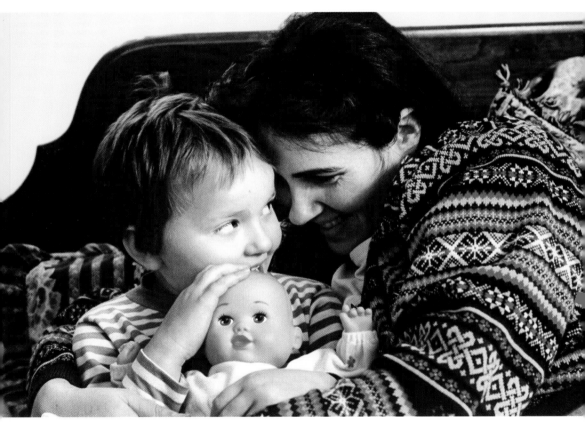

NEW LEASE ON LIFE
In 1996, having battled brain cancer into remission, Dorothy Moran
is happy to be home with Mom in Alexandria, Virginia. Thirteen
years later, Dorothy is a healthy young adult.
Photograph by Vickie Lewis

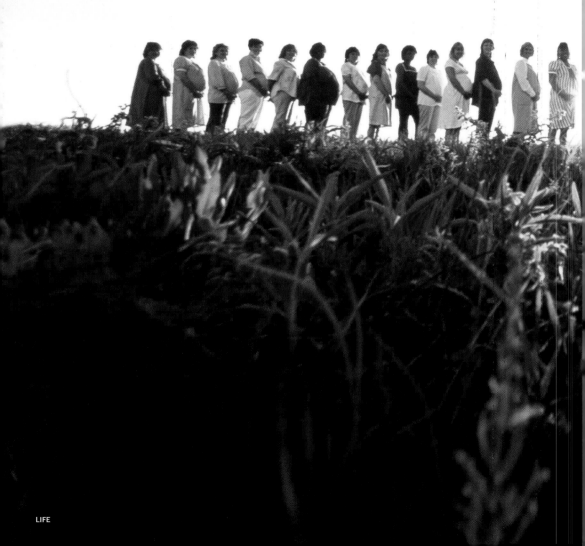

"Youth fades; love droops; the leaves of friendship fall;
A mother's secret hope outlives them all."
— Oliver Wendell Holmes, Chief Justice of the Supreme Court

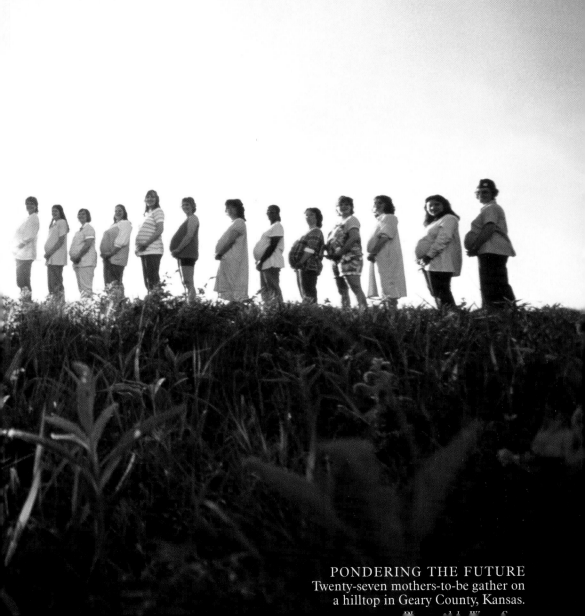

PONDERING THE FUTURE
Twenty-seven mothers-to-be gather on
a hilltop in Geary County, Kansas.

"To understand a mother's love, bear your own children."

— Chinese proverb

THE TIES THAT BIND
Lula Wright of Letcher County, Kentucky, takes a determined walk to her garden, with the help of her daughter-in-law Juanita.
Photograph by Karen Kasmauski

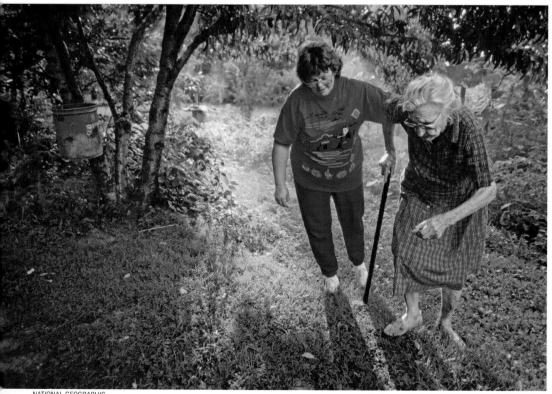

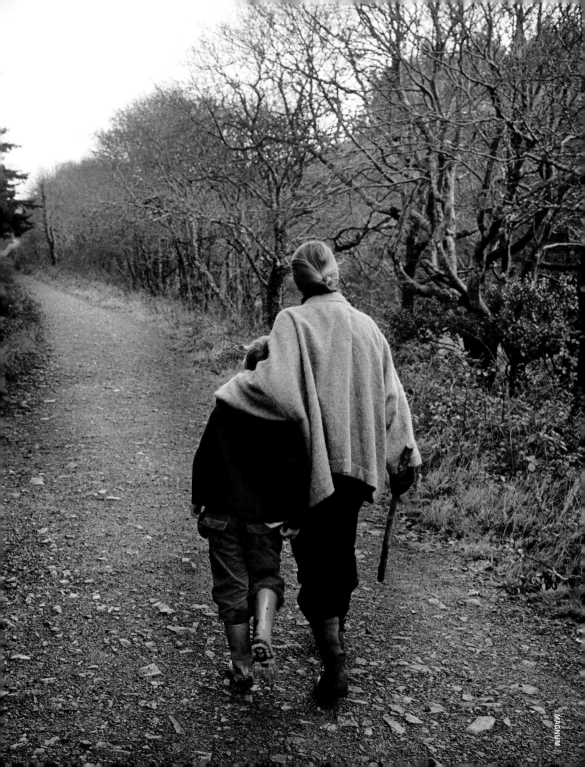

"Some mothers are kissing mothers and some are scolding mothers, but it is love just the same, and most mothers kiss and scold together."

— Pearl S. Buck, American writer

RITE OF PASSAGE
In Rajasthan, India, a bride weeps goodbye to her mother.
Photograph by Jodi Cobb

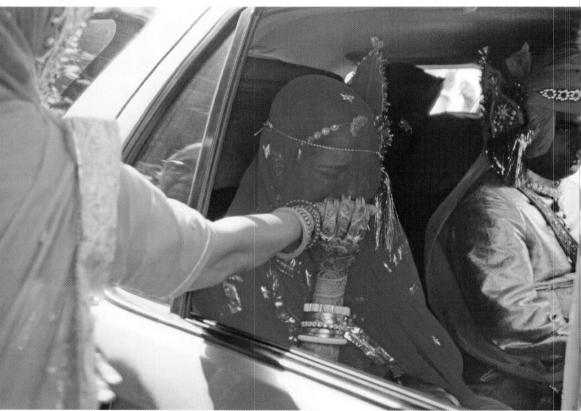

MAINE IDLES
While Emily plays with her donkey,
her mother, Joan, tries in vain to interest her in Nancy Drew.
Photograph by Michael E. Ach

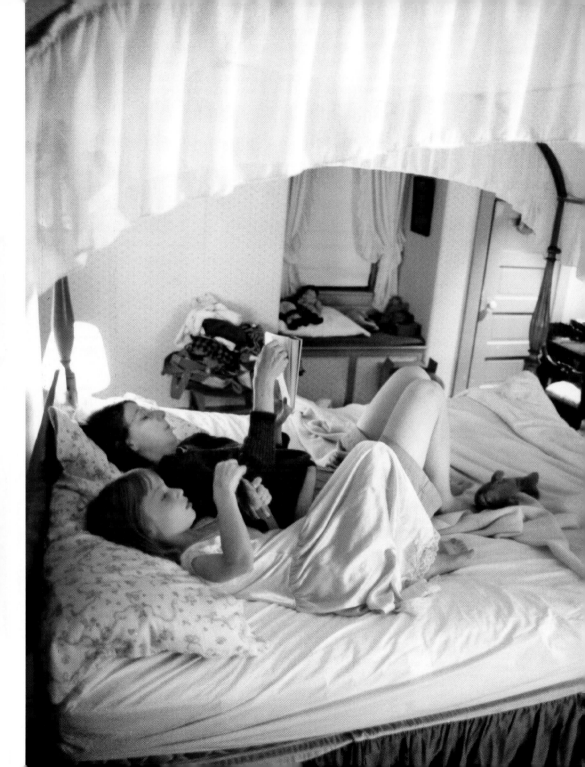

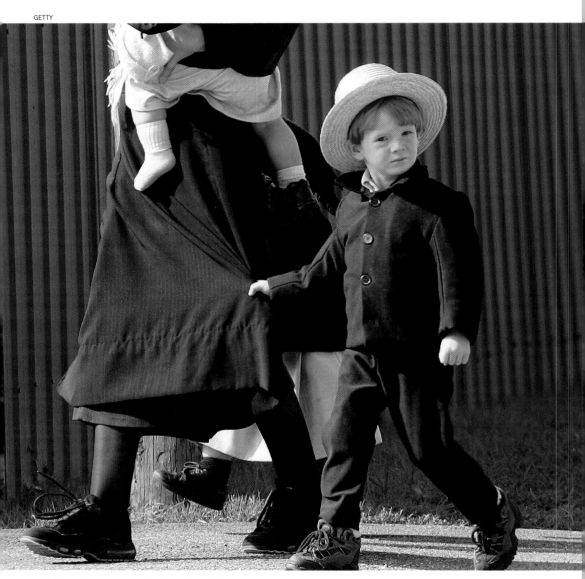

FAITH AND FORGIVENESS
An Amish mother and her children quietly arrive in the town of Nickel Mines, Pennsylvania, to attend the funeral of a young victim of the 2006 Amish school shooting.
Photograph by Timothy A. Clary

"I remember my mother's prayers and they have always followed me. They have clung to me all my life."

— Abraham Lincoln, 16th President of the United States

SMALL BEGINNINGS
In Bath, Maine, Pia wonders at the miracle of her son Finn.
Photograph by Heather Perry

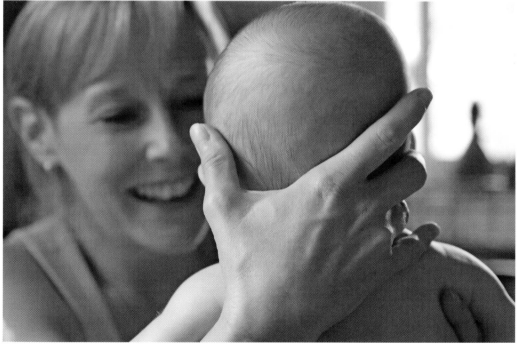

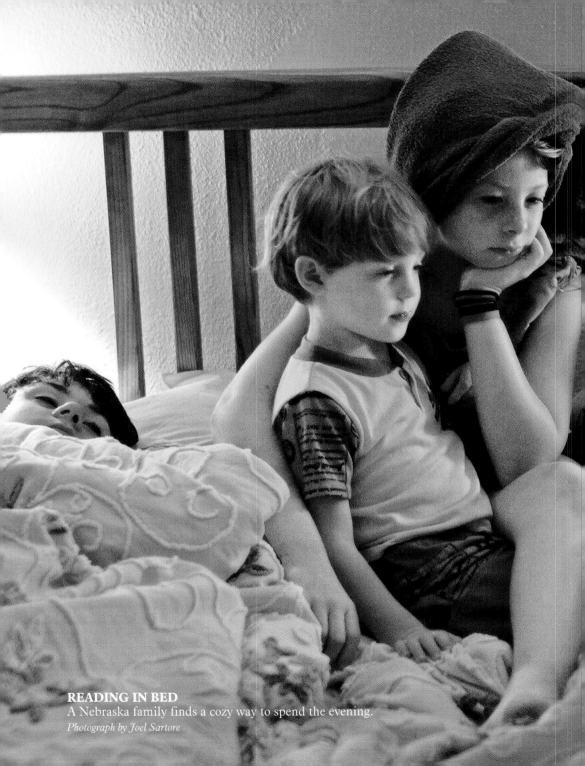

READING IN BED
A Nebraska family finds a cozy way to spend the evening.
Photograph by Joel Sartore

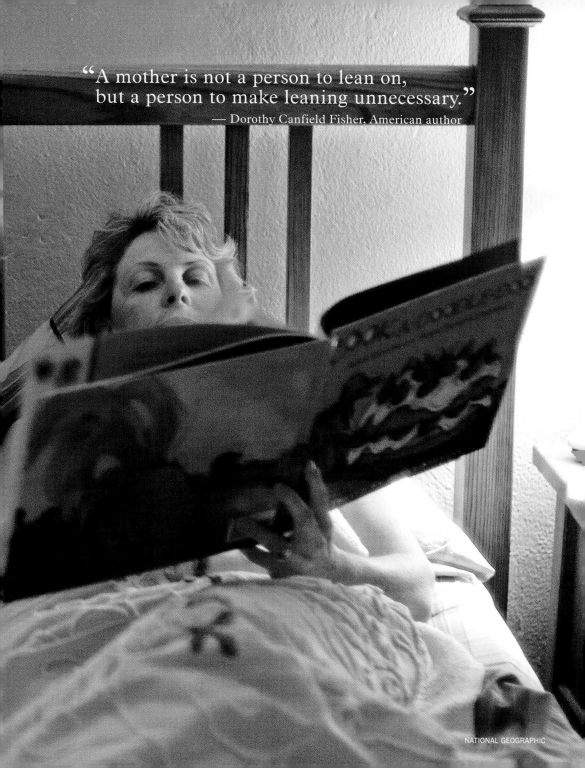

"A mother is not a person to lean on,
but a person to make leaning unnecessary."
— Dorothy Canfield Fisher, American author

"The mother's heart is the child's schoolroom."

— Henry Ward Beecher, American clergyman

LOVE AND KISSES
Michelle Obama beams at her daughter Sasha as she blows a kiss to a video of her father, Barack Obama, at the 2008 Democratic National Convention in Denver, Colorado.

Photograph by Win McNamee

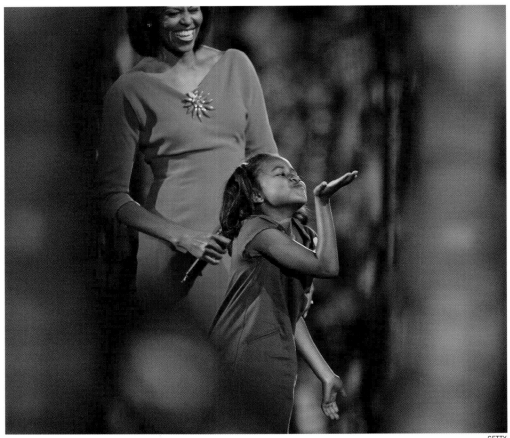

GETTY